REMBRANDT & BRITAIN

Christian Tico Seifert

National Galleries
of Scotland

D0335494

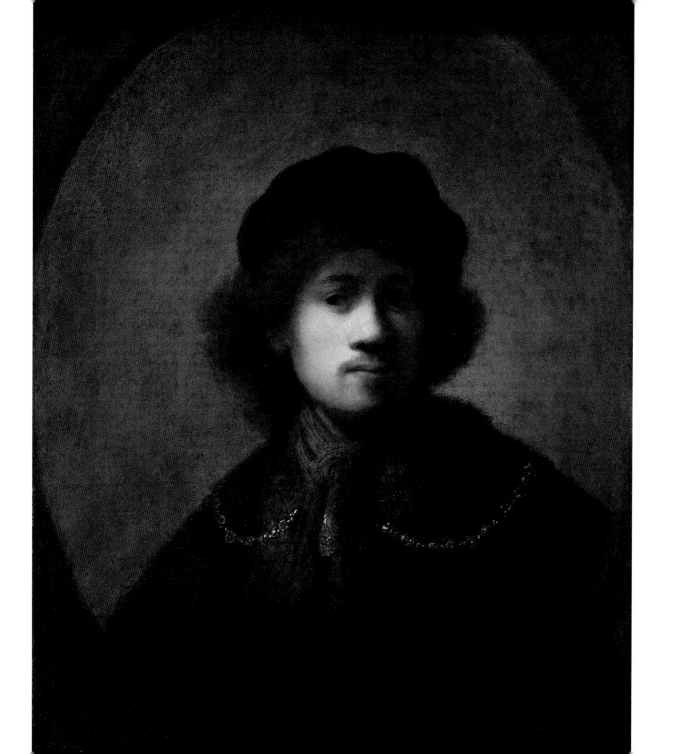

REMBRANDT AND BRITAIN

Rembrandt van Rijn (1606–1669), who spent his entire career as a painter, draughtsman and printmaker in the Dutch Republic, enjoyed considerable fame beyond his home country and throughout Europe during his lifetime. In recent decades, his imagery has become ubiquitous, making him a global brand like few other artists in history.

The son of a miller, Rembrandt was born and trained in Leiden. He worked in Amsterdam, mainly as a portrait painter, for a few years before he settled there in 1633. Rembrandt married in 1634 and enjoyed a successful career as painter and printmaker in Amsterdam, receiving important private and public commissions. He nevertheless ran into financial difficulties – most likely due to an enormous mortgage on his house and substantial expenses towards his art collection – and was declared insolvent in 1656. After his large house and possessions had been sold, he continued to work in Amsterdam until his death.

In recent decades, his imagery has become ubiquitous, making him a global brand like few other artists in history

The story of Rembrandt's art in Britain, and of how it inspired collectors, artists and writers, is exceptionally rich. In the seventeenth century, Rembrandt was predominantly known for his etchings. Few paintings and drawings seem to have been in the country before the final decade, when the art market in London grew to international importance and the taste for Rembrandt's art developed. The eighteenth century was marked by the discovery of the artist and sophisticated collecting, culminating in what contemporaries described as a 'craze' for Rembrandt's works. The nineteenth century saw a re-evaluation of Rembrandt's reputation, combined with widening access through public collections, exhibitions and mass reproductions, including photography and, towards 1900, the sale of many prized paintings to Germany and the United States. Rembrandt was the main stimulus for the etching revival, which continued into the twentieth century. Many modern artists were attracted to Rembrandt, as are a number of contemporary artists, evidence that the Dutch master continues to inspire in the twenty-first century.

Figure 1. Rembrandt (attributed to), *Self-portrait*, c.1629
Oil on panel, 72.3 x 57.8 cm
National Museums Liverpool,
Walker Art Gallery, Liverpool

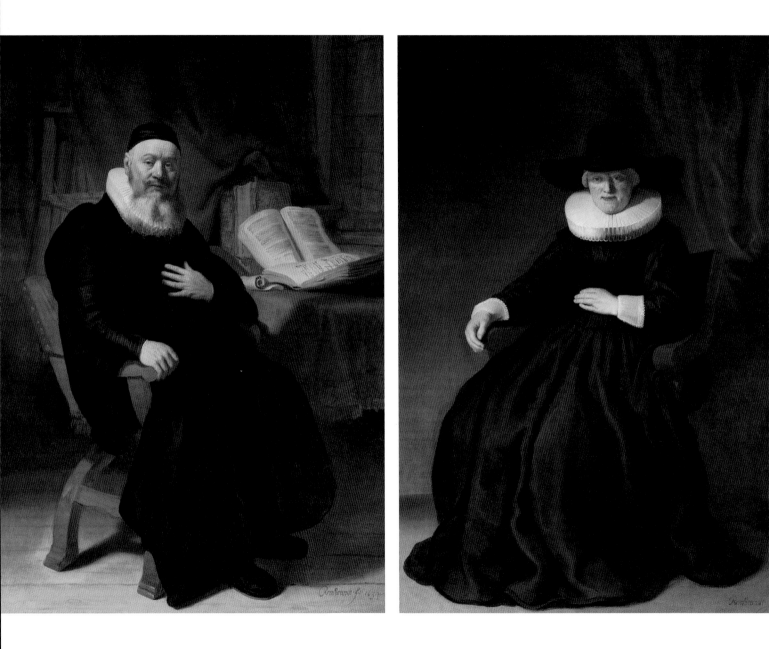

A slow start:
the seventeenth century

Evidence for paintings by Rembrandt in seventeenth-century Britain is scarce. King Charles I (r.1625–49), who amassed one of the greatest art collections of all time, probably took little notice of Rembrandt, the emerging star of the Dutch Golden Age. Yet, by serendipity rather than through ambition, he became the first collector to own paintings by Rembrandt not only in Britain but anywhere beyond the Dutch Republic. Two of the three in his possession can be identified: *Self-portrait* (fig.1) and *An Old Woman, c.*1629 (Royal Collection). Sir Robert Kerr, who was created Earl of Ancrum in 1633, visited the Netherlands on a diplomatic mission in January 1629, and it is widely assumed that he acquired the three paintings on this occasion. However, it is difficult to reconcile such an early date for the two surviving paintings – neither of which bears either signature or date – with Rembrandt's dated works from 1628–29, and the attribution of these two works to Rembrandt has been contested by some scholars in recent years. The question of authenticity, which recurs throughout the history of collecting Rembrandt's art and still

endures today, was already encapsulated in those first arrivals to Britain.

Such uncertainties never befell Rembrandt's only portraits of sitters from Britain: a pair, both signed and dated 1634 (figs 2 and 3). Johannes Elison and his wife Maria Bockenolle lived in Norwich, where he was a minister in the Dutch Reformed Church. Around 1634 they visited their son Joan in Amsterdam, and he probably commissioned the two full-length portraits from Rembrandt. Such expensive and ostentatious portraits are uncommon for clerics (and indeed rare in Rembrandt's work) and presumably reflect the status of their son, a successful merchant, more than the sitters' own aspirations. The only visual reference to their home is the distinctly English hat Maria is wearing. The couple's portraits remained with Joan in Amsterdam. They were inherited by his sister Anne and brought to Yarmouth in 1680. The portraits remained in the family until they were sold in 1860. They were acquired by the Museum of Fine Arts in Boston in 1956, and the 2018 exhibition at the National Galleries of Scotland marks the

Figure 2. Rembrandt, *Reverend Johannes Elison*, 1634
Oil on canvas, 174 × 124.5 cm
Museum of Fine Arts, Boston

Figure 3. Rembrandt, *Maria Bockenolle (Wife of Johannes Elison)*, 1634
Oil on canvas, 174.9 × 124.1 cm
Museum of Fine Arts, Boston

Figure 4. Rembrandt (attributed to), *View of St Albans Cathedral*, 1640
Pen and brown ink, brown wash and black chalk, 18.4 × 29.5 cm
Teylers Museum, Haarlem

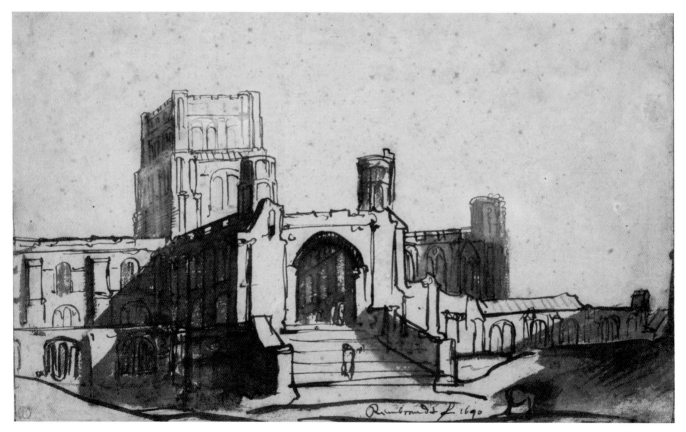

first time they have returned to the United Kingdom since 1929.

A few years after the visit from the Norwich minister and his wife, Rembrandt was again busy exploring English subjects. A group of four drawings depicting English views, shown together for the first time at the 2018 exhibition in Edinburgh, have been much debated. Two of them are signed and dated 1640, although some scholars doubt these inscriptions and reject the attribution of all four to Rembrandt. However, the most important aspect for our story is that, on stylistic grounds, all four drawings must have been created in Rembrandt's studio in about 1640. This raises the intriguing question of Rembrandt's source for these views, as the artist is unlikely ever to have set foot on British soil. The locations – St Albans Cathedral (fig.4), Windsor Castle and London with Old St Paul's (twice) – are clearly identifiable. Yet there are inaccuracies regarding details of the buildings and the topography. For example, the transept of St Albans has been transformed into a monumental entrance with broad stairs and an open hall. It seems improbable that Rembrandt (or any Dutch artist of this period) would have taken such liberty on site. However, no prints have been identified as Rembrandt's models. It is more likely that he relied on drawings that fellow artists brought back from England.

The knowledge of Rembrandt's art in Britain in the seventeenth century, and almost all writings on it, rely on his etchings. John Evelyn's eulogy, published in 1662 in his *Sculptura*, the first history of printmaking ever, reflects an appreciation that we must assume was gained first-hand. He was the earliest English writer to refer to individual etchings of 'the incomparable Reinbrand'.[1]

The evidence for collecting Rembrandt's etchings in Britain in the seventeenth century is, again, limited but confirms the existence of two different types of print collectors which can broadly be described as 'image collectors' and 'works collectors'. The former predominantly were led by what prints depicted, the latter by which artist had made or designed them. The best-known in the first category is the famous diarist Samuel Pepys, whose collection is preserved virtually

Figure 5. Unknown artist, *Portrait of Fabian Smith
(Ulyanov), Agent for the English Merchants to the
Emperor of Muscovia, c.1666–80*
Oil on canvas, 76 × 64 cm
Guildhall Art Gallery, City of London

unaltered at Magdalene College, Cambridge. His two impressions of Rembrandt's *Ecce Homo*, 1655 and *The Three Crosses*, 1653, are of remarkable quality. However, he described them as drawings, without recording the artist's name. We may assume that he was unaware that they were by Rembrandt. Pepys's classification may seem astonishing today, but it underlines that, for him, the image was more important than the artist.

When Richard Maitland, 4th Earl of Lauderdale, sold his enormous collection of about 10,000 prints in 1689 – certainly one of the largest compiled in Britain to that date – the auctioneer listed one lot 'Renbranti Opera integra, four hundred and twenty Figures'.[2] This is the first evidence in Britain for an album or portfolio that contained the entire oeuvre of Rembrandt's prints – an extraordinary feat. Such a comprehensive collection had surely been acquired *en bloc* in or from the Netherlands.

The earliest traces of Rembrandt's impact on British art refer to his etchings. They include Richard Gaywood's *Democritus Laughing and Heraclitus Weeping in front of a Globe*, c.1650–60, which is a pastiche after two etchings by Jan Gillisz van Vliet (after Rembrandt's design); and Edward Lutterell's pastels after Rembrandt etchings, produced around 1700.

A fascinating and perhaps unique case of appropriating an etching by Rembrandt is the portrait of Fabian Smith, agent from 1613 to 1631/32 of the Muscovy Company that held exclusive privileges in trade between Britain and Russia (fig.5). It has been suggested that an earlier portrait of Smith was lost in the Great Fire of London in 1666 and that the present one was commissioned soon after by the company as a replacement. As Smith's features were no longer known, the artist modelled it on Rembrandt's etching *Bearded Man Wearing a Velvet Cap with a Jewel Clasp*, 1637, perhaps attracted by the beard and exotic attire which seemed to fit a successful merchant who had spent much of his time in Moscow.

> Pepys's classification [...] underlines that, for him, the image was more important than the artist

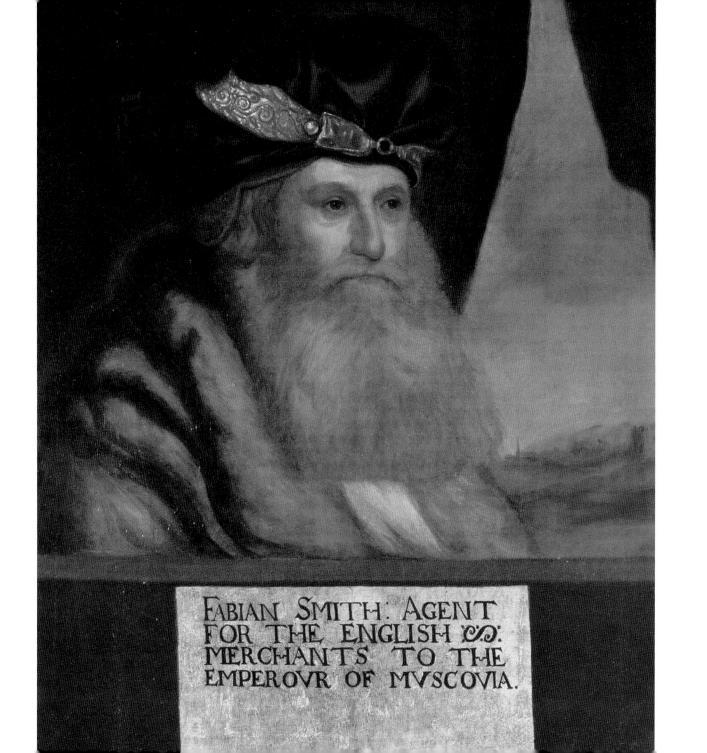

FABIAN SMITH: AGENT
FOR THE ENGLISH &:
MERCHANTS TO THE
EMPEROVR OF MVSCOVIA.

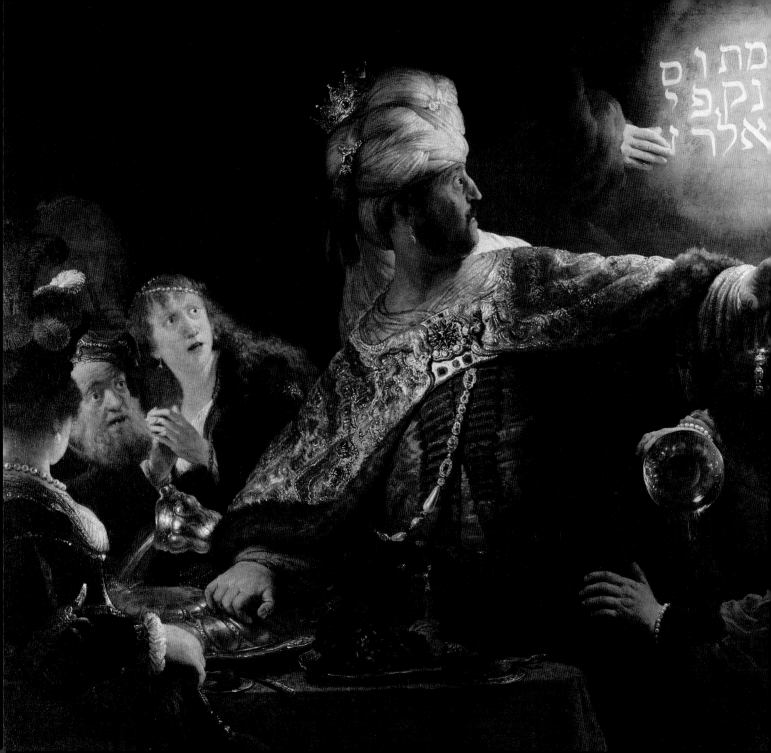

'The craze': the eighteenth century

The eighteenth century saw a constantly growing European art market, albeit with occasional dips resulting from wars, and London soon became its centre. Rembrandt's reputation rose out of the shadow of the heroes of Italian and – in smaller number – French art, such as Raphael, Titian, Correggio and Claude, who remained on their pedestals into the late nineteenth century. The taste for Rembrandt's art had developed first in the Netherlands and then in France, and the earliest biography and critical assessment of his work to be published in English was Roger de Piles's *The Art of Painting*, translated from the French in 1706. He criticised Rembrandt's lack of interest in the ancient and Italian masters, as well as his preference for 'nothing more than to imitate nature'. However, more importantly, he described the merits of Rembrandt's paintings, drawings and etchings, emphasising his powerful colouring and chiaroscuro. His portraits – for which British collectors would develop a lasting preference – are 'expressive and lively' and praised for their 'truth of likeness'.[3] These characteristics shaped the perception of Rembrandt's art for nearly two centuries.

From about 1720, the towering figure of Rembrandt's discovery in Britain was Jonathan Richardson the Elder, whose eminence chiefly rests on his writings and his substantial collection of drawings by the artist. In his writings, he celebrated Rembrandt's inventions, expression and composition and added critical praise on individual artworks, some of which were in his collection. Richardson's collection of Rembrandt drawings, one of the finest ever assembled in Britain, included *The Calumny of Apelles*, c.1652–54 (British Museum, London), a copy after a drawing from the early 1500s by the Italian artist Andrea Mantegna (also in the British Museum). Later distinguished owners included Arthur Pond, John Barnard, Benjamin West and Sir Thomas Lawrence. *The Calumny of Apelles* epitomises the rising fame of individual drawings. The marks left on them by their owners – from Richardson onwards – created a pedigree that confirmed authenticity and importance, as well as increasing their value.

The other important collection of Rembrandt drawings of this period was dominated by an unparalleled group of landscapes. In 1723,

William Cavendish, 2nd Duke of Devonshire, acquired at least 225 drawings from Nicolaes Flinck, whose father Govert Flinck had trained with Rembrandt in the 1630s. Nicolaes Flinck's collection in Rotterdam was regarded as one of the best in all of Europe.

The first major paintings by Rembrandt began appearing in Britain from about 1720: a little trickle that would grow into an enormous surge during the following decades. This included the late *Self-portrait*, 1669 (The National Gallery, London), which arrived before 1722; *The Circumcision*, 1661 (National Gallery of Art, Washington), which followed before 1724; *Belshazzar's Feast* (fig.6), which came in about 1729–30; and *Landscape with the Rest on the Flight into Egypt* (fig.7), which was in the country by 1749.

Arthur Pond, a portrait painter like Richardson, was the other eminent champion and collector of Rembrandt's art in early Georgian London. He is most famous for one of the finest collections of the master's etchings ever formed. Pond was also a shrewd businessman and recognised

Figure 6 (pp.10–11). Rembrandt, *Belshazzar's Feast*, c.1636–38
Oil on canvas, 167 × 209.2 cm
The National Gallery, London

Figure 7. Rembrandt, *Landscape with the Rest on the Flight into Egypt*, 1647
Oil on panel, 34 × 48 cm
National Gallery of Ireland, Dublin

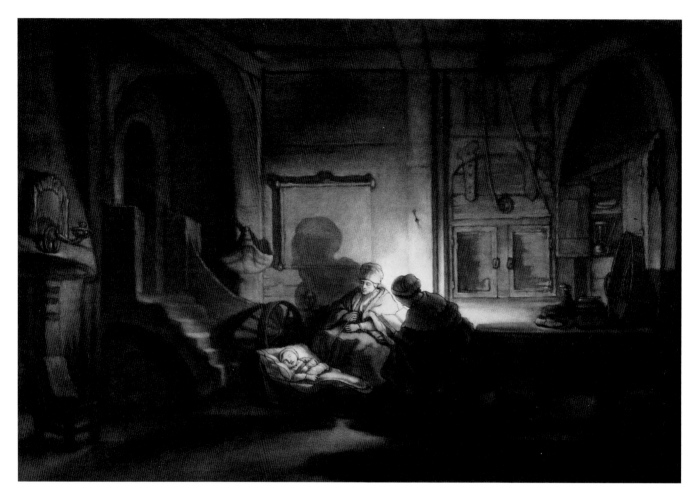

Figure 8. James McArdell, after
Rembrandt (workshop), *A Dutch
Interior ('The Cradle')*, c.1765
Mezzotint, 34 × 46.6 cm
David Alexander

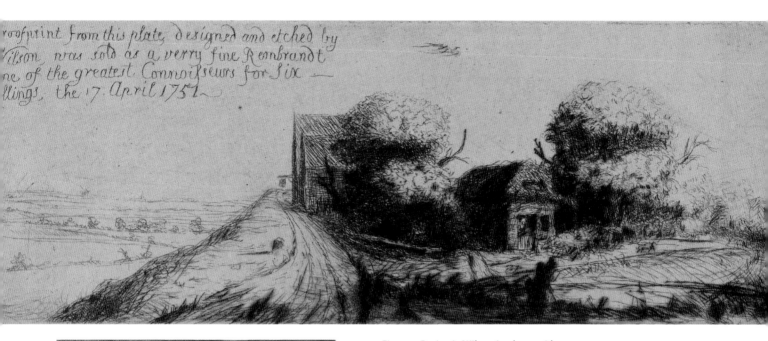

roofprint from this plate, designed and etched by
Wilson was sold as a verry fine Rembrandt
ne of the greatest Connoisseurs for Six
llings, the 17. April 1751.

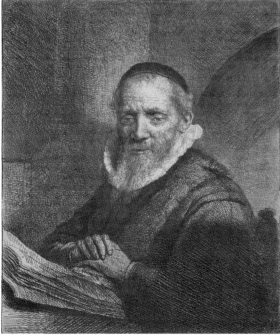

Figure 9. Benjamin Wilson, *Landscape with
a Road and Two Houses in the Centre*, 1751
Etching and drypoint, 6.1 × 17.3 cm
British Museum, London

Figure 10. Rembrandt,
Portrait of the Preacher Jan Cornelis Sylvius, 1633
Etching, printed in red ink, 16.4 × 14 cm
National Galleries of Scotland, Edinburgh

the huge potential of printmaking to multiply images of artists' paintings and drawings. Increasingly, printmakers discovered that mezzotint was particularly well suited to capturing the chiaroscuro (the strong contrast of light and dark) of Rembrandt's works (fig.8). Mezzotint shares expressive qualities with Rembrandt's etchings in the 'dark manner', and he was sometimes (erroneously) credited with the invention of this technique. The dissemination of prints such as these rose steeply from around the middle of the century, making Rembrandt's imagery available to a much wider and less wealthy audience.

By this time, a veritable Rembrandt mania was in full swing, particularly where his etchings were concerned. This was so much the case that it, and Rembrandt's art, became the target of criticism and satire. The engraver and chronicler of the art world George Vertue observed in 1751 that Rembrandt prints had latterly become 'much esteemed and collected at any price'.[4] The artist and

scientist Benjamin Wilson infamously deceived the painter-collector Thomas Hudson and others, including Pond, in 1751 with a fake Rembrandt etching he himself had fabricated (fig.9). In the aftermath of this spoof, fellow artist William Hogarth, a friend of Wilson, issued a subscription ticket (a print sold

By this time, a veritable Rembrandt mania was in full swing, particularly where his etchings were concerned

for a receipt, as a down-payment for another, more elaborate and expensive, print) ridiculing Dutch art which proved so popular that he reprinted it, lettered 'Design'd and Etch'd in the rediculous manner of Rembrant'.

The Paris dealer Edme-François Gersaint's critical catalogue of Rembrandt's etchings was translated into English in 1752. Collectors now had a tool to identify different states, copies and forgeries. At the same time, Gersaint's

book fuelled the craze for rarities such as corrected proof impressions and counterproofs, and impressions on oriental papers and vellum (a practice revived and commercially exploited during the etching revival). To fulfil this desire for the uncommon, printers who were fortunate enough to have access to the original plates pulled new editions, sometimes creating collectors' items that Rembrandt himself never produced; for example, impressions on satin or in red ink (fig.10).

Reprints and copies catered to the huge demand for Rembrandt's etchings in a competitive market, with dwindling resources of the ever-more-expensive originals. Captain William Baillie infamously acquired the worn plate of *The Hundred Guilder Print*, one of Rembrandt's most famous etchings. He reworked it and in 1775 printed a limited edition (fig.11), thereafter cutting the plate into four pieces and continuing to print from these mutilated fragments. This 'Madness to have his [Rembrandt's]

Figure 11. Rembrandt, reworked by William Baillie,
The Hundred Guilder Print, c.1648 and 1775
Etching and engraving, 28.2 × 39.8 cm
Nicholas Stogdon

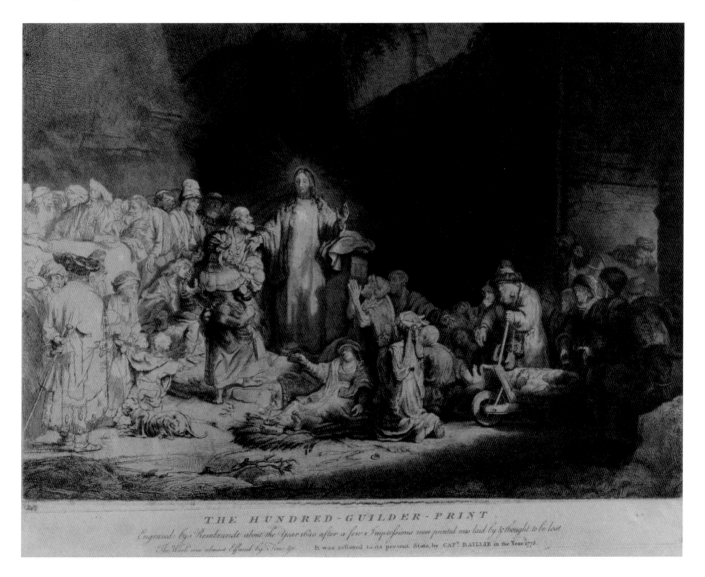

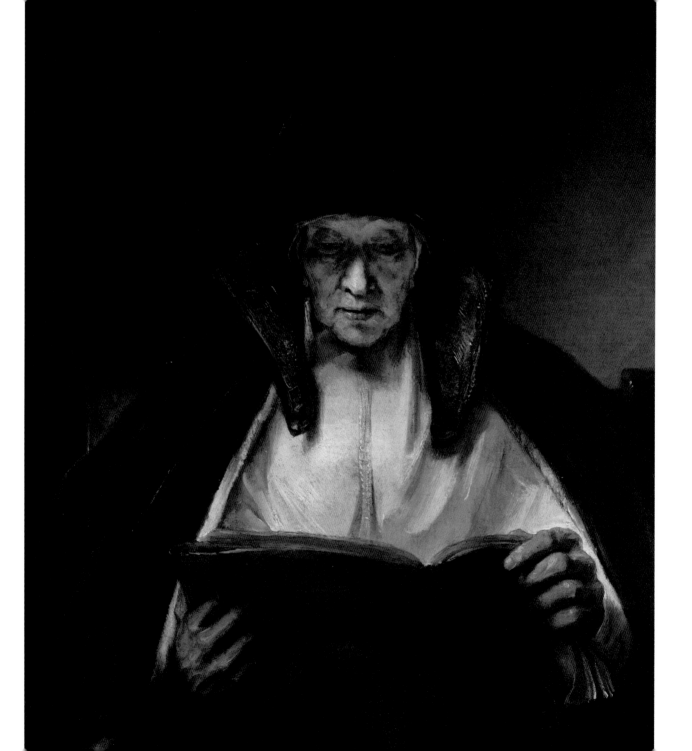

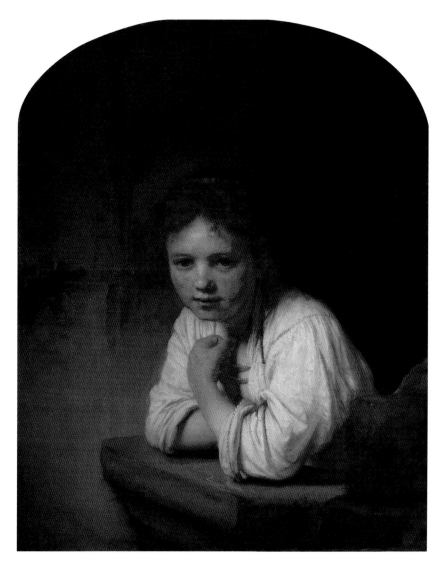

Figure 12. Rembrandt, *An Old Woman Reading*, 1655
Oil on canvas, 78.7 × 66 cm
Buccleuch Collection

Figure 13. Rembrandt, *Girl at a Window*, 1645
Oil on canvas, 81.8 × 66.2 cm
Dulwich Picture Gallery, London

Prints' was ridiculed by the famed writer and connoisseur Horace Walpole, who complained in his 1763 *Anecdotes of Painting in England* that 'he [Rembrandt] is so well known, and his works [are] in such repute, that his scratches, with the difference only of a black horse or a white one, sell for thirty guineas'.[5] Walpole also commented on a somewhat mysterious claim that Rembrandt may have visited Hull in 1661: 'Vertue was told by old Mr. Laroon, who saw him in Yorkshire, that the celebrated Rembrandt was in England in 1661, and lived 16 or 18 months at Hull.'[6] Walpole himself seems to have doubted this story, not least because he must have realised that Marcellus Laroon the Elder, whom he believed to be Vertue's source, would only have been about eight years old when meeting Rembrandt. Moreover, in 1661–62, Rembrandt was working on two major public commissions in Amsterdam, and it seems highly unlikely that he would have left the city during this busy period.

Meanwhile, it was observed that by 1770 'genuine works of this master [Rembrandt] are rarely to be met with, and whenever they are to be purchased they afford incredible prices.

Many of them are preserved in the rich collections of the English nobility.[7] This emphasis on the shortage of genuine works implies an increasing number of doubtful attributions and forgeries under Rembrandt's name. During this period, however, some prized pictures were acquired by British collectors, such as *An Old Woman Reading* (fig.12) before 1765, *Girl at a Window* (fig.13) before 1774, and *A Woman in Bed (Sarah)*, *c.*1647 (National Galleries of Scotland) about 1776, which were all reproduced in mezzotint prints. The success of mezzotints after Rembrandt's paintings peaked around 1780, although many of them continued to be sold into the nineteenth century.

What impact did the massively enhanced exposure to Rembrandt's imagery have on artists in Britain? With the exception of *The Mill* (fig.14), which had such a lasting effect on landscape artists in the nineteenth century, British painters chiefly took inspiration from Rembrandt for portraits and self-portraits. From William Hogarth, Thomas Hudson, Joseph Wright of Derby and Allan Ramsay to Sir Henry Raeburn (fig.15) and Sir Thomas

Lawrence, painters were, in different ways, inspired by Rembrandt's technique, motifs and, above all, colouring and chiaroscuro. His impact takes a wide range of forms, from subtle hints in colouring and the distribution of light and shade to recognisable references and outright plagiarism. However, these works tend to be isolated in the respective artists' oeuvres.

Above all, it was Sir Joshua Reynolds who absorbed Rembrandt as an artist, writer and collector. His Rembrandt collection was one of the most distinguished in Britain, including prized paintings such as *A Man in Armour* ('*Achilles*') (fig.16). The strongest impact on Reynolds as a portraitist lasted from about 1745 to about 1770. The *Portrait of Giuseppe Marchi*, 1753 (Royal Academy of Arts, London), of Reynolds's chief studio assistant, and his *Self-portrait* from around the same time (fig.17), both show strong chiaroscuro combined with warm colouring and – in the former – fancy oriental costume, all reminiscent of Rembrandt's paintings. Reynolds had a keen interest in the master's

British painters chiefly took inspiration from Rembrandt for portraits and self-portraits

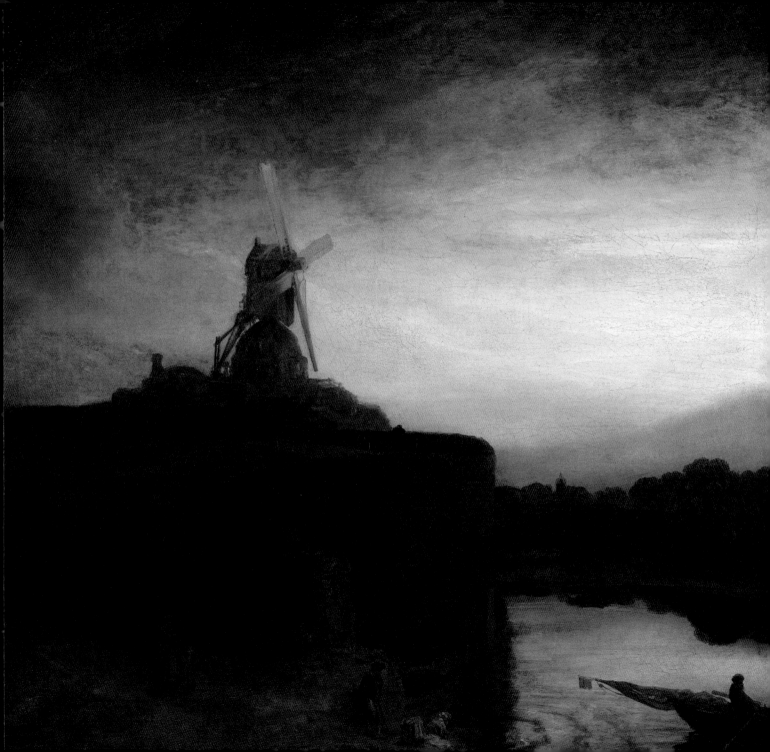

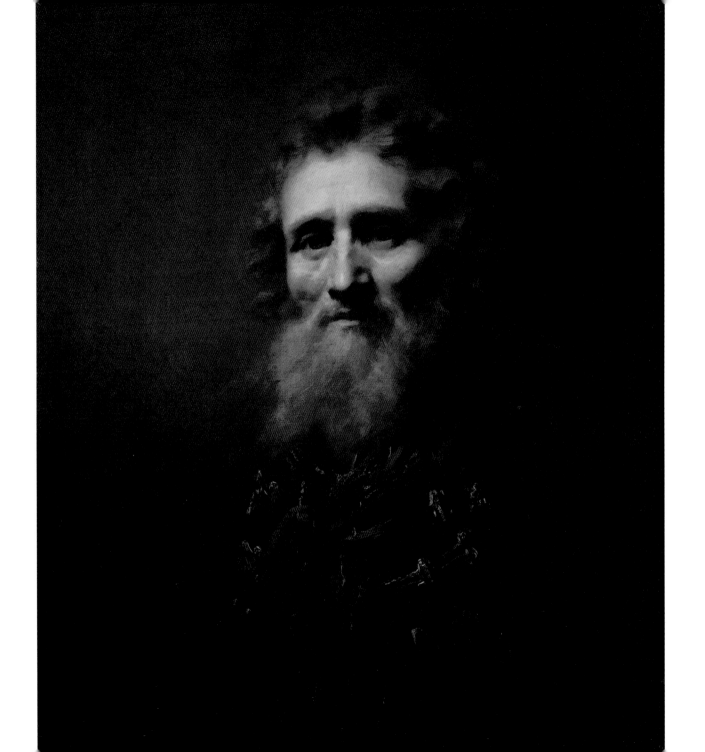

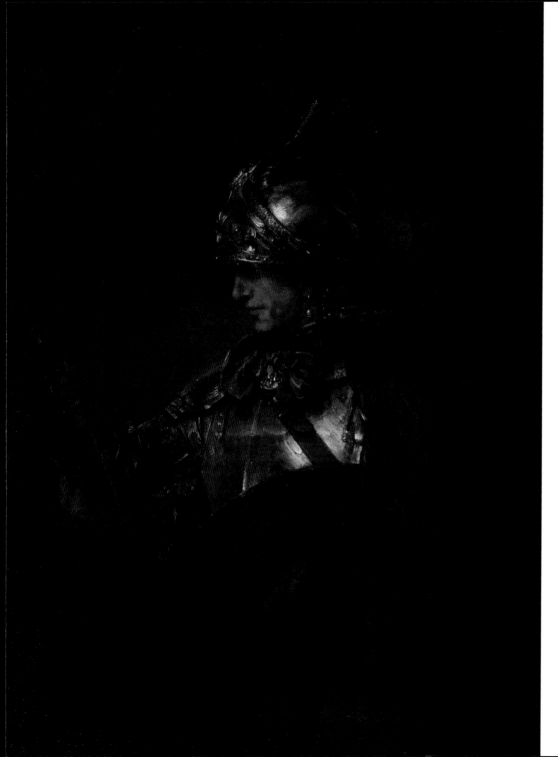

Figure 15. Henry Raeburn, *Portrait of a Jew*, 1814
Oil on canvas, 76.2 × 63.5 cm
National Galleries of Scotland, Edinburgh

Figure 16. Rembrandt, *A Man in Armour ('Achilles')*, 1655
Oil on canvas, 137.5 × 104.4 cm
Glasgow Life (Glasgow Museums) on behalf of Glasgow City Council

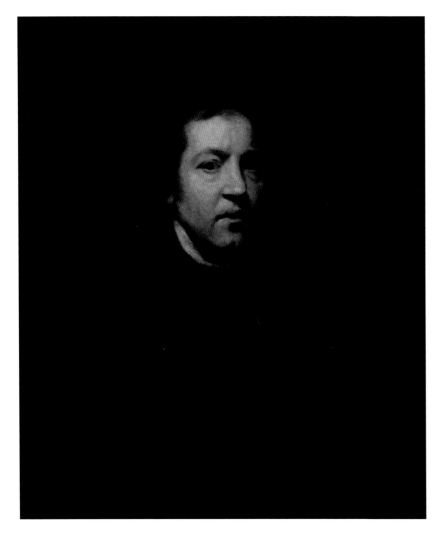

Figure 17. Joshua Reynolds,
*Self-portrait when Young, c.*1753–58
Oil on canvas, 73.7 × 61.6 cm
Tate

technique, and recent technical examination of Rembrandt's paintings from his collection has found evidence that he repainted these, although the degree to which he did so remains under discussion. In his *Discourses* – lectures delivered to young artists and dominated by Italian art – Rembrandt unsurprisingly only features a few times and as an example to avoid rather than to follow. Likewise, when Reynolds visited the Netherlands in 1781, he was much more taken by Sir Peter Paul Rubens than by Rembrandt, whose *The Night Watch*, 1642 (Rijksmuseum, Amsterdam) he found 'the worst of him I ever saw'.[8]

At the end of the eighteenth century, which had seen such a meteoric rise of Rembrandt's art and its reputation in Britain, the market was flooded with dubious works under his name. In 1792, the anonymous author of an article in the *London Chronicle* titled 'Hints to collectors of pictures' put it more bluntly: 'if you lay hold of a little pannel, plaistered over with a dirty compound, the colour of chalk and charcoal, without it being possible to discover a form, or guess what the artist intended, call it a Rembrandt'.[9] The market was overheated, and the craze drew to a close.

Re-evaluations:
the nineteenth century

Collecting of Rembrandt's works continued, of course, and benefited from the repercussions of the French Revolution and the Napoleonic Wars, which released an enormous number of artworks from distinguished collections onto the British market. The most famous of these collections was that of the Duc d'Orléans, which included Rembrandt's *The Mill* (fig.14). Among other prized paintings, the near-contemporary *Self-portrait* (fig.18) and *Titus at his Desk*, 1655 (Museum Boijmans Van Beuningen, Rotterdam) were also first documented in Britain around 1800. Many of these treasures were acquired by a new class of wealthy collectors, such as the Barings, who sold their collection to King George IV (r.1820–30), and John Julius Angerstein, whose bequest on his death in 1823 became a foundation stone of the National Gallery in London. George IV, 'the most acquisitive British monarch since Charles I', was the first to collect paintings by Rembrandt.[10] (Charles I (r.1625–49) and George III (r.1760–1820) had 'accidentally' acquired works by the artist, the latter when he purchased the collection of Consul Smith from Venice in 1762.) George IV's celebrated trophy was *The Shipbuilder and his Wife*, 1633 (Royal Collection), purchased in 1814 for a staggering 5,000 guineas.

Sir Thomas Lawrence's fabulous collection of drawings, one of the finest ever assembled in Britain, included many cherished Rembrandts; it was dispersed following his death in 1830. The eminent collector Richard Payne Knight, who also owned *The Holy Family at Night* ('*The Cradle*'), c.1642–48, then believed to be by Rembrandt (Rijksmuseum, Amsterdam), bequeathed his collection to the British Museum upon his death in 1824; it included sixty-three drawings then regarded as by Rembrandt. Collecting of Rembrandt's etchings continued to flourish, albeit without the craziness of the mid-eighteenth century. British collections overall tended to grow until the latter part of the century, when many of them came onto the market and considerable numbers of paintings, drawings and prints by Rembrandt were sold and left the country.

Two major shifts dominate the reception of Rembrandt's art in the nineteenth century: his changing reputation and an exponential rise in access to his art through

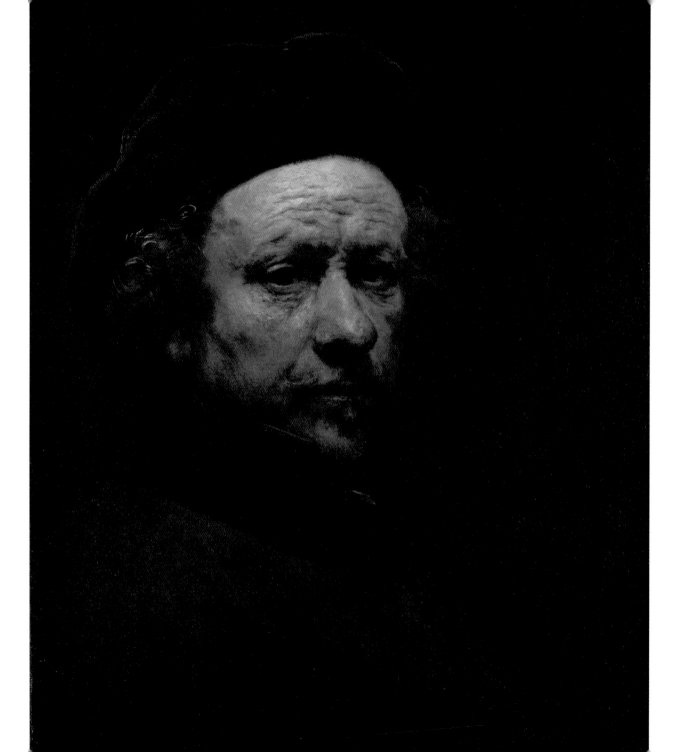

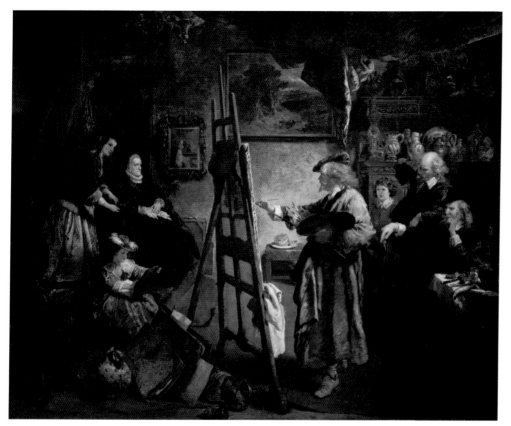

Figure 18. Rembrandt,
Self-portrait, c.1655
Oil on canvas, 52.7 × 43 cm
National Galleries of Scotland,
Edinburgh (Bridgewater
Collection Loan)

Figure 19. John Gilbert, *Rembrandt's
Studio*, 1869
Oil on canvas, 121.9 × 152.5 cm
York Museums Trust, York

public collections and reproductive images. Rembrandt's reputation, simplified, was transformed by his work no longer being measured against purely academic rules, which ultimately allowed his elevation to a universally celebrated genius. From de Piles to Reynolds, Rembrandt's achievements, chiefly in colouring, chiaroscuro and expression, had been contrasted with his shortcomings in design, vulgar subject matter and his adherence to nature as opposed to the ideals of ancient and Italian art. Although criticism of, for example, Rembrandt's nudes did not disappear altogether, it became part of the wider notion of a 'gigantic but barbarous genius', as Henry Fuseli described him in a lecture given in London in 1802.[11]

This liberation from academic rules legitimised an increased interest in Rembrandt's personality and fuelled the urge to discover the person through his art and to interpret the artworks as

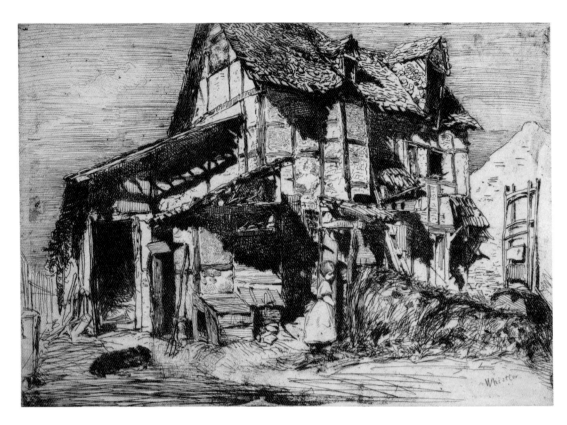

Figure 20. James Abbott
McNeill Whistler,
The Unsafe Tenement, 1858
Etching, 15.8 × 22.6 cm
The Hunterian, University
of Glasgow, Glasgow

products of Rembrandt's life (rather than the complex social, historical and cultural context that he was part of). The Romantic image of Rembrandt, as well as his art, thus began to emerge. Ultimately, Rembrandt himself became the subject in art and popular culture. The Victorian era produced sumptuous paintings depicting imaginary scenes from the artist's life (fig.19) as well as occurrences such as artist Sir John Lavery dressing up as Rembrandt on the occasion of the Grand Costume Ball organised by the Glasgow Art Club in 1889.

At the same time, access to Rembrandt's artworks beyond the circles of collectors and connoisseurs was constantly widened through the foundation of museums and galleries, and through exhibitions. In 1799, the British Museum received the bequest of the Revd Clayton Mordaunt Cracherode, which included some 500 etchings by Rembrandt – about half the present holdings.

The founding bequest of the Dulwich Picture Gallery (1811) included three paintings by Rembrandt; the National Gallery opened in 1824 with two, but acquired another

thirteen before 1900. The British Institution started its popular annual loan exhibitions in 1815, and no fewer than nineteen paintings under Rembrandt's name were shown, four of which have been included in the 2018 exhibition in Edinburgh. Rembrandt's works were a constant presence in these exhibitions, and he was represented exceptionally strongly among the *Art Treasures* in Manchester in 1857.

Prints had been the prime medium for disseminating Rembrandt's imagery since the mid-eighteenth century, but the introduction of cheap reproduction techniques permitted an unprecedented popularisation. The invention of photographic processes allowed for ever-more-reliable reproductions, which were increasingly used to illustrate books.

What did all this mean to artists in the nineteenth century? Traditionally, British portraitists had been taking inspiration from Rembrandt's art, and this continued into the twentieth century. Perhaps starting with Joseph Mallord William Turner, landscape painters discovered Rembrandt. *The Mill* epitomises this more than any other landscape painting, inspiring artists throughout the century, including Turner, John Crome and John Constable.

Beyond portraiture and landscape, Rembrandt also became the model for history painters such as Sir David Wilkie, whose watercolour *Burying of the Scottish Regalia*, 1836 (National Galleries of Scotland) was inspired by *The Entombment* that William Hunter had bequeathed to the University of Glasgow in 1783. Rembrandt had become an all-embracing artistic model, albeit selectively employed.

Rembrandt also became the model for applied arts, such as stained glass, porcelain plaques and ivory carvings. Early portrait photography was often compared to Rembrandt's works. The photography pioneers David Octavius Hill and Robert Adamson created personality and atmosphere through tonality and chiaroscuro, and Hill described their *Portrait of Spencer Compton*, 1843–47 as 'a singularly Rembrandtish & very fine study'.[12]

The etching revival was the dominating artistic phenomenon inspired by Rembrandt's art in the second half of the century. Receiving its first impulse from France, its chief protagonists in Britain were Sir Francis Seymour Haden, who was also a major collector of Rembrandt's etchings, and his brother-in-law James Abbott McNeill Whistler (fig.20). The revival was a small, highbrow offshoot of the Victorian market for inexpensive printed images; and it was Whistler, in 1880, who invented several of the presentation techniques which are still standard among printmakers, including adding a signature by hand and the limiting of editions.

The modern era

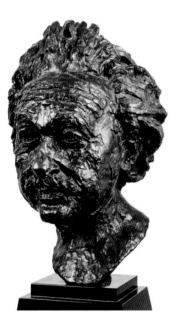

There were periods when Rembrandt was a vital source of inspiration, in the late 1890s and early 1900s, and then again in the 1960s, and periods where his pathos, attachment to the human figure and expressive brushwork have seemed less relevant.

The events which did most to galvanise interest in Rembrandt in the modern era occurred late in 1898, when the Stedelijk Museum in Amsterdam, and then in 1899 the Royal Academy in London, mounted the biggest-ever exhibition of Rembrandt's work; arguably the first 'blockbuster' old-master exhibitions.

In his 1954 autobiography, Augustus John described the profound effect it had on him: 'As I bathed myself in the light of the Dutchman's genius, the scales of aesthetic romanticism fell from my eyes, disclosing a new and far more wonderful world'.[13] A key appeal for John seems to have been the intense, interrogatory quality of Rembrandt's self-portraiture, most keenly felt in his smaller etchings and drawings, for example *Tête Farouche* (fig.22).

Others who were roughly the same age as John, and moved in the same circles, and whose work touched upon Rembrandt around the same time at the turn of the century, include William Orpen, Sir William Nicholson, Sir William Rothenstein and Sir George Clausen. None of them copied or slavishly imitated Rembrandt, but in their works done around 1900, certain Rembrandt-esque tropes and mannerisms can be noted – vast, dark interiors which dwarf the figures; penetrating, stagey stares; moody candle lighting; yellow, red and brown glazes; and painterly brushwork.

What is striking is that this interest in Rembrandt was brief: it is characteristic of British painting of the late 1890s and early 1900s, and then fizzles out. This dearth of committed followers is perhaps due to two factors. In the first place, Rembrandt's work was so famous and his style so individual (albeit often confused with work by his studio and followers) that close imitation seemed pointless. Secondly, the 1910s and inter-war period saw the rise of other, rival styles and factions. Edwardian portrait artists such as Sir John Lavery and John Singer Sargent were more interested in the fiery, flashy brushwork of Frans Hals, the master of Dutch

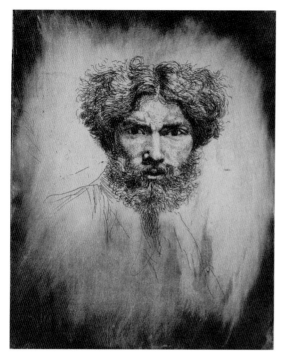

Figure 22. Augustus John, *Tête Farouche (Portrait of the Artist)*, c.1901
Etching, 21.3 × 17.1 cm
National Galleries of Scotland, Edinburgh

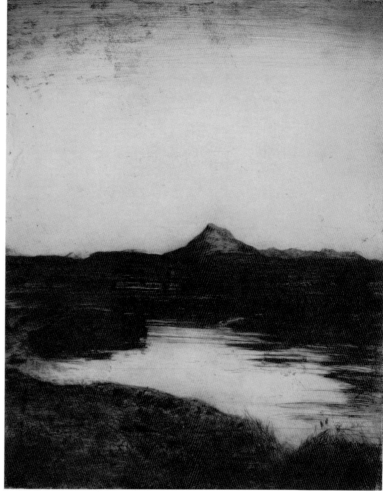

Figure 23. David Young Cameron, *Ben Ledi*, 1911
Etching and drypoint, 38 × 30.3 cm
National Galleries of Scotland, Edinburgh

Figure 21. Jacob Epstein, *Albert Einstein*, 1933
Bronze, 43.5 × 30 × 25.5 cm
National Galleries of Scotland, Edinburgh

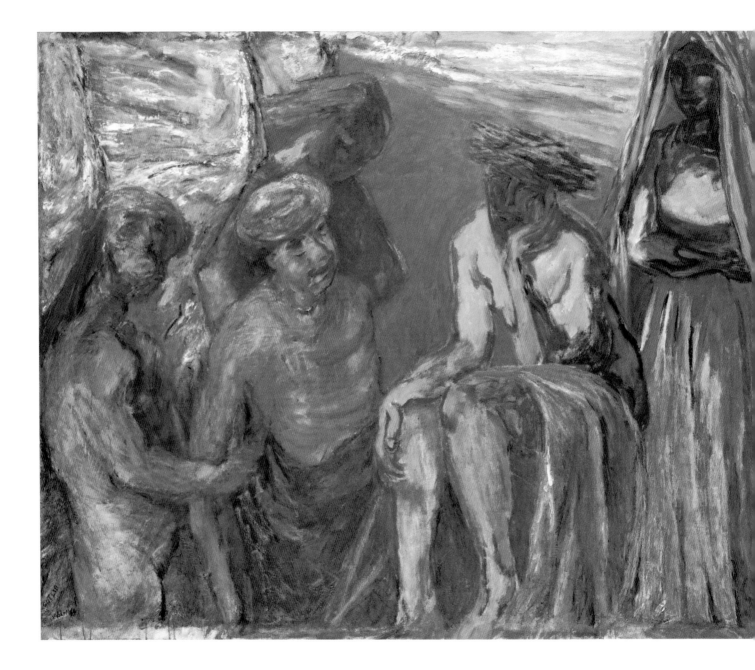

Figure 24. Henryk Gotlib, *Rembrandt in Heaven*, c.1948–58
Oil on canvas, 133.3 × 163.2 cm
Tate

Golden-Age portraiture, and Édouard Manet, who had paved the way for Impressionism. However, for etching, Rembrandt continued to be the gold standard throughout the early decades of the twentieth century in the work of the second-generation 'etching revival' artists including James McBey, Sir David Young Cameron, Sir Muirhead Bone and William Strang. Their moody landscapes, done with drypoint and surface tone, were much in fashion among specialist print collectors and fetched huge prices in Europe and America. An impression of Cameron's *Ben Ledi* (fig.23) sold for £640 in 1929, making it more expensive than many original Rembrandts. Such prices allowed the artists to collect Rembrandt's work: Cameron and McBey both did so. But the Wall Street Crash of 1929 and the global financial collapse which ensued brought about a parallel collapse in the print market and all but snuffed out the mania for Rembrandt-esque etchings.

Perhaps surprisingly, one of Rembrandt's greatest advocates during the 1930s was a sculptor, Sir Jacob Epstein. For him, Rembrandt was 'the greatest of all artists. He had every quality – all the plastic qualities and all life as well.'[14] Epstein's fingered modelling technique acts as a sort of analogue to Rembrandt's vital brushwork. One of his sitters even came out looking like the Dutch master: when modelling Albert Einstein's bust (fig.21), Epstein commented that 'His glance contained a mixture of the humane, the humorous and the profound. This was a combination which delighted me. He resembled the ageing Rembrandt.'[15]

But, with a few exceptions like Epstein, Rembrandt was too famous to follow. Instead, homages took the form of cigarette cards and films (Charles Laughton played him in the eponymous 1936 film), and his name was appropriated as a byword for quality, to sell artists' products. The Rembrandt Head Gallery, which specialised in prints, operated in central London at 5 Vigo Street from about 1880 to 1930; a bronze bust of the artist is still *in situ*, high above the entrance door. The Edinburgh gallery Doig, Wilson & Wheatley had 'Rembrandt Edinburgh' as their telegram address. Much later, Rembrandt's name and face were used to sell things as various as beer, toothpaste and kitchen appliances.

During the Second World War, the pictures at the National Gallery in London were sent to safe storage in Wales. But in 1941, when Rembrandt's *Portrait of Margaretha de Geer*, c.1661 was acquired, a letter to *The Times* prompted its display, alone, in an otherwise pictureless National Gallery. When the sculptor Sir Eduardo Paolozzi was studying at the Ruskin School of Art in Oxford during the War, he actually lived in the Ashmolean Museum for a while, being stationed there as a night-time fire officer. He made copies of facsimile reproductions of Rembrandt's etchings in the Ashmolean library.

Through some ninety self-portrait paintings and etchings which span his whole career, Rembrandt is the artist

Figure 25. Leon Kossoff, *From Rembrandt:
A Woman Bathing in a Stream*, 1982
Oil on board, 58.4 × 48.3 cm
Private collection

par excellence of ageing, decay and death. He is the artist to whom artists look when considering their own mortality. Henryk Gotlib began his homage to Rembrandt, *Rembrandt in Heaven* (fig.24), in 1948 when he was seriously ill and approaching death (or so he thought: the diagnosis turned out to be wrong); he said that before dying he wanted to pay homage to Rembrandt. It seems he was the natural artist to turn to in times of adversity.

In the 'Swinging Sixties', Rembrandt began to look old-fashioned – too earnest and heartfelt for the times. For the new breed of Abstract Expressionist and Pop Artist, he was a museum artist, of little relevance to their own work and lives. But abstraction and, later, conceptual art did not reign supreme. Among a hard-core group of figurative artists who emerged in the 1950s, the so-called 'School of London' group, Rembrandt was profoundly relevant. They included Lucian Freud, for whom Rembrandt was one of the undisputed giants and an artist he liked to measure himself up

to. Freud never copied Rembrandt, but fellow School of London group members Leon Kossoff and Frank Auerbach, who have been close friends for more than sixty years, have done so, voraciously, over many decades. Kossoff has made drawings and etchings after several paintings by Rembrandt in the National Gallery collection, including *A Woman Bathing in*

a Stream (fig.25). Like Kossoff, Auerbach has spent a lifetime scrutinising the art of the past: 'Rembrandt at the National Gallery. I went every day, for a long time. I drew from paintings then drew them as if I'd drawn them myself.'[16] Works that he has copied, or made variants after, include *A Woman Bathing in a Stream*, 1654 and *Belshazzar's Feast* (fig.6).

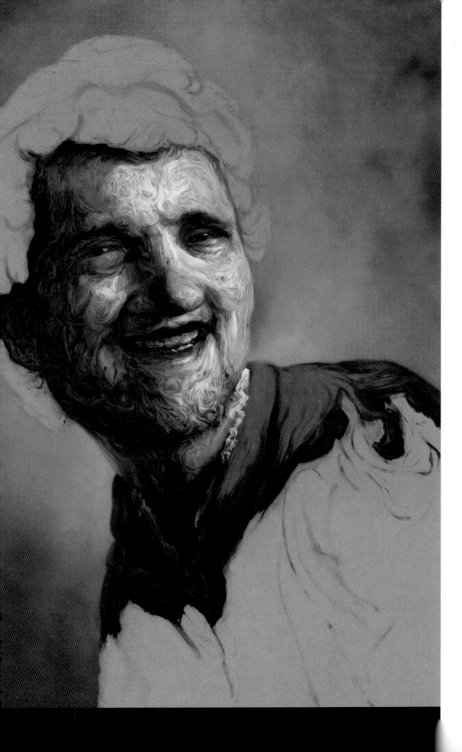

Figure 26. Glenn Brown, *Unknown Pleasures*, 2016
Oil on panel, 164 × 105.5 cm
Courtesy the artist

Many others have borrowed from Rembrandt in recent years. John Bellany, for example, did so in direct homages such as *Danae: Homage to Rembrandt II*, 1991 (The Bellany Estate), and above all in self-portraits, which chart years of alcoholism, illness and recovery that echo Rembrandt.

Other, younger artists have viewed Rembrandt in a way that may seem cynical or disrespectful but which turns out to be the opposite. Glenn Brown has made painted, drawn and etched variants after Rembrandt since 1996 (fig.26). Brown tackles the surface appearance of the work, highlighting the curious relationship that exists in paintings between style and subject. The process of replication involves computer technology, and Rembrandt would surely have been interested in it had he been the same age as Brown. It is a backhanded but deeply felt homage.

Rembrandt's work is so ubiquitous in terms of reproduction, and so sanctified by talk of his profound humanity and his enormous prices, that it is good to have this all punctured now and again, so that we can look at the works afresh.

Endnotes

1. John Evelyn, *Sculptura, or the History and Art of Chalcography and Engraving in Copper, with an Ample Enumeration of the Most Renowned Masters and Their Works*, London, 1662, p.81.

2. *Pinacotheca Maitlandiana or, a Catalogue of the Lord Maitland's Prints and Drawings by the most Eminent masters of Europe (…)*, sale London (Ben J. Walford), 20 January 1689, p.13, lot 326.

3. Roger de Piles, *The Art of Painting*, London, 1706, pp.316–20.

4. George Vertue, Note Books III, *Walpole Society*, vol.22 (1933–34), p.159.

5. Horace Walpole, *Anecdotes of Painting in England*, vol.3, Strawberry Hill, 1763, p.4.

6. Ibid., pp.3–4, n.†.

7. Matthew Pilkington, *The Gentleman's and Connoisseur's Dictionary of Painters: Containing a Complete Collection, and Account, of the Most Distinguished Artists (…)*, London, 1770, p.508.

8. Christopher White, 'Rembrandt: Reputation and collecting', in: Christopher White, David Alexander and Ellen D'Oench, *Rembrandt in Eighteenth-Century England*, New Haven, 1983, pp.13–14.

9. 'Hints to collectors of pictures', *London Chronicle*, 12 July 1792, p.38.

10. James Stourton and Charles Sebag-Montefiore, *The British as Art Collectors, from the Tudors to the Present*, London, 2012, p.187; Christopher White, *Dutch Pictures in the Collection of Her Majesty The Queen*, London, 2015, pp.36–50.

11. Ralph N. Wornum (ed.), *Lectures on Painting, by the Royal Academicians, Barry, Opie, and Fuseli*, London, 1848, p.473.

12. Sara Stevenson, *Facing the Light: The Photography of Hill & Adamson*, exh. cat., Edinburgh (National Galleries of Scotland), 2002, p.38, no.20.

13. Augustus John, *Chiaroscuro: Fragments of Autobiography*, London, 1954, p.28.

14. As reported by R.H. Wilenski in *Britannia and Eve*, 26 October 1928, p.421.

15. Jacob Epstein, *Let There be Sculpture*, London, 1942, p.78.

16. Robert Hughes, *Frank Auerbach*, London, 1990, p.7.

Acknowledgements

The modern era is an abridged and slightly amended version of Patrick Elliott's essay published in Christian Tico Seifert *et al.*, *Rembrandt: Britain's Discovery of the Master*, exh. cat., Edinburgh (National Galleries of Scotland), 2018.

Published by the Trustees of the National Galleries of Scotland to accompany the exhibition *Rembrandt: Britain's Discovery of the Master* held at the Scottish National Gallery, Edinburgh, from 7 July to 14 October 2018.

Text © 2018 the Trustees of the National Galleries of Scotland

ISBN 978 1 911054 26 9

Printed on GardaMatt Ultra 150gsm by Albe de Coker

Designed and typeset by Caleb Rutherford e i d e t i c

Front cover: Rembrandt, *Landscape with the Rest on the Flight into Egypt*, 1647
National Gallery of Ireland, Dublin
(detail of fig.7)

Title page: Rembrandt, *A Man in Armour ('Achilles')*, 1655
Glasgow Life (Glasgow Museums) on behalf of Glasgow City Council
(detail of fig.16)

Back cover: Augustus John, *Tête Farouche (Portrait of the Artist)*, c.1901
National Galleries of Scotland, Edinburgh
(detail of fig.22)

All rights reserved. No part of this publication may be reproduced, or transmitted, in any form or by any means, electronic or mechanical, including photocopy, recording or any other information storage and retrieval system without prior permission in writing from the publisher.

This exhibition has been made possible with the assistance of the Government Indemnity Scheme provided by Scottish Government.

National Galleries of Scotland is a charity registered in Scotland (no.SC003728)

Copyright and Photographic Credits

Fig.1 Walker Art Gallery, National Museums Liverpool / Bridgeman Images; fig.2 Bredius 200; RRP A 98. William K. Richardson Fund, 56.510; photograph © 2018 Museum of Fine Arts, Boston; fig.3 Bredius 347; RRP A 99. William K. Richardson Fund, 56.511; photograph © 2018 Museum of Fine Arts, Boston; fig.4 TEYLERS MUSEUM HAARLEM THE NETHERLANDS; fig.5 Guildhall Art Gallery, City of London; fig.6 © The National Gallery, London. Bought with a contribution from the National Art Collections Fund, 1964; fig.7 photo © National Gallery of Ireland; figs 8 & 10 photography © National Galleries of Scotland; fig.9 © The Trustees of the British Museum; fig.11 photo: Adrian Arbib; fig.12 by kind permission of the Duke of Buccleuch & Queensberry KBE; fig.13 by Permission of Dulwich Picture Gallery, London; fig.14 courtesy National Gallery of Art, Washington; fig.15 presented by Mrs F.C. Holland 1948; photography John McKenzie © National Galleries of Scotland; fig.16 given by Jane Graham Gilbert, 1877. © CSG CIC Glasgow Museums and Libraries Collections; fig.17 © Tate, London 2018; fig.18 photography Antonia Reeve © National Galleries of Scotland; fig.19 image courtesy of York Museums Trust :: http://yorkmuseumstrust.org.uk/ :: CC BY-SA 4.0; fig.20 © The Hunterian, University of Glasgow 2018; fig.21 © ESTATE OF JACOB EPSTEIN; presented by the children of James Watt and his wife Menie, in their memory 1958; photography by A. Reeve © National Galleries of Scotland; fig.22 © The Estate of Augustus John / Bridgeman Images; purchased 1949; photography © National Galleries of Scotland; fig.23 The Hon. Gertrude Forbes-Sempill Gift 1955; photography © National Galleries of Scotland; fig.24 © The Estate of the Artist, the late Henryk Gotlib/Tate, London 2018; fig.25 © the Artist; fig.26 © Glenn Brown. Photo Mike Bruce. Courtesy the artist and Gagosian.